T0108426

# Like A Beast of Colours, Like A Woman

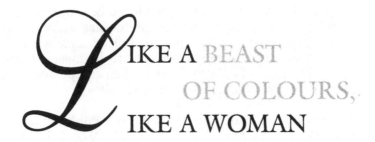

# LIKE A BEAST OF COLOURS, LIKE A WOMAN

## SOPHIA KASZUBA

Porcepic Books
*an imprint of*

Beach Holme Publishing
Vancouver

This book is published by Beach Holme Publishing, #226—2040 West 12th Ave., Vancouver, BC, V6J 2G2. This is a Porcepic Book.

We acknowledge the generous assistance of The Canada Council and the BC Ministry of Small Business, Tourism and Culture.

The Canada Council | Le Conseil des Arts
FOR THE ARTS | DU Canada
SINCE 1957 | DEPUIS 1957

Editor: Joy Gugeler
Production and Design: Teresa Bubela

Cover Art: *Red Canna* by Georgia O'Keeffe, c. 1923. Oil on canvas mounted in masonite, 91.4 x 76.0 cm. Collection of the University of Arizona Museum of Art, Tucson, Gift of Oliver James. Acc No. 50.1.4.

Canadian Cataloguing in Publication Data:

Kaszuba, Sophia
    Like a beast of colours, like a woman

(A Porcepic Book)
Poems.
ISBN 0-88878-383-3

    I. Title. II. Series.

PS8571.A86755L45 1998     C811'.54     C98-900287-X
PR9199.3.K38L45 1998

This book is dedicated to my beloved

*Robert W. Reid*
*19 May 1937 - 15 June 1997*

# Contents

# Blue Door

in the throat is
a blue door into
a room of ghosts

# LIKE A BEAST OF COLOURS, LIKE A WOMAN

*I*

The girl carries the photograph
to show to friends.
Someone once told her
if she concentrated
the door in the photograph would open.
It is white when she looks at it.
She imagines white,
it and nothing else.

*II*

The size of the heart is in the breath.
Behind it a woman is whistling
a colour out of her body,
a body that is blue or yellow
we cannot see. Green leaves surround the voice.
The tree is opening its sex to speak,
the heart deep in the voice.

*III*

The woman moves in and out of the photograph
through a perforation in the light.

# Highway 10

Tonight along Highway 10,
the evening will release the trees from the heat,
open the deep dark avenue of cool shadows,
and the line of cars will follow each other
deeper into the hard beautiful land up north,
the Milky Way flowing like
a field of white ermine over night grass,
the roadside redolent with dew and settling heat,
and the crickets of Paradise,
Lorca's fierce violinists, singing
dark fiery lust and heaven all night.

# ONE HEADLIGHT BUSTED

My breasts are a place to come and put your head,
dark curls turned to baby's hair.

How I grew up? In one fast breath,
out of all the places I lived,
Charleroi, Kirkland Lake, Toronto,
Wiarton, and then another breath.

Up the hill on the highway of evergreens
in the pickup truck with one headlight busted
to visit a friend by the lake,
deep in the woods down a dirt road
with bumblebees over the weeds in the ditch.

How do you move inside a summer's day?
Like a hummingbird and a warrior,
like a woman in her best skirt
when she knows men are watching,
and she holds everything still
for one long moment
before she turns and looks back.

# BALANCE

I'm walking up Highway 6 to Tobermory,
quiet on the highway.
The fields lie under the coloured clouds.
The east side of the road is carved out of the forest,
the west side, fawn-coloured with furrowed loam.
Morning light is pushing the great limestone
boulders back into the ground.
I've got the power back,
to see in all directions,
my balance back, to walk straight.

# WE LEFT THE CITY AND MOVED NORTH

South below where the Shield
cracked three million years ago
we left behind a city of taxis,
streets of black haired women
holding gladiolus, laughing

we moved through the metal snow
past the articulate fragrance
of coffee
all the delicious poisons of the city
billboards and streetcars

north, towards a frozen lake
the size of a province
and we promised each other everything
this:
remoteness, a still centre,
and more
a necklace of pine cones
one of Jupiter's moons
little Io
for a reflector

we said, "This land is the lamp of heaven"
quiet to each other
the train slow through
New Liskeard, Cobalt,
Kirkland Lake
(to Moosonee)

I made holes in the ice of the window
a hole into night

(dreams of the bush)

we held hands, dozed
in the white gaze
of the close sub-Arctic
moving into the long dawn
drunk on beer
and the smell of beginnings

# Town under the Lake

I didn't think nature could be
a religion up north,
canoes on the lake,
the old white rowboat drifting
near the summer island.

When winter stars shone in the snow
I read Rousseau with a flashlight,
and the blood whistled,
oracular and northern. But I
wanted romance, the hot summer,
weeping willows trailing humidity
in the dusky green mists
of the city in the south.

Trees creak in the frost. The stars shine on the snow.
The night rests a long time in the will
and you give yourself up to the gigantic cold.
It eats the lungs.
Between the head and heart,
you lack everything and want it
and don't know where it is.

# *L*AKE HURON IN FOG

We are in the lake. A storm over Midland
is moving this way. The water is warmer
than the air. Mist surrounds us
like at the top of a mountain
or in a hot spring.

It is very dark everywhere,
the colour of the black cloud
that holds rain and opens
with a fork of lightning.

We are swimming through the lake's halo
as if flying through a cloud
with the moon on one side
and the sun on the other.
We jump up and down in the buoyant water.
A sea gull cries from a lamp post.
Water foams behind our legs as we swim
like Red Bay's fish in June
by the reeds of the shore
where they come to spawn, carp
turning circles
one on top of the other,
the water closing over them
they over the water,
thick with body.

# SKYE LAKE

We are rowing in the gleaming dark water
under the great sky, with sun
streamers hanging from a cloud in the west.
The whole jumble of darkness and light
moves back and forth as we row
to the shore of Skye Lake
through the water lilies and reeds
to the small rotting dock that Matt said
he would replace and did not.

Carol is in the kitchen watching out the window.
And under the shifting light she can see
the whole south shore of hay stubble
in yellow and antique gold
like the gold-foil work of the Persians,
pictures in a book she bought long ago.

We row swiftly to get home,
with deep strokes in the blue black water
and from the sky there is a quaking
of something large seeking shape
and great shots of light are tearing the sky
like the illuminations around saints
in the paintings of masters.

# THE CHORUS  *(for Robert on 19 May 1996)*

All day the sun shone on my darling's birthday.
A hot southwest wind blew in the afternoon.
At evening it rained, slowly long drops into the dark.
The porch light attracted a frog, separated
from the chorus in the stream, courting alone,
away from the loving over and over in the water.

Later, the wind blew up a storm and lightning forked
and tore the eastern sky, breaking the air apart
crashing thunder over the frogs in the stream.
The thousands sang on and on about the rain,
about wetness and bogs and everything that flowed.
Their song called to the lightning inside things,
the fingers of water lacing the green reeds.

The little house of spit waved on its blade of grass.

We stayed inside the room, just touching,
woven into the thoughts we wove all day
going to sleep with them,
turned homeward by the night.

*Robert W. Reid, 19 May 1937 - 15 June 1997*

# IN THE POEMS BY BOBROWSKI

The long deep summers by the river
swim in mist in the mornings
crowned by sleep under the sky of stars
above the field of crickets,
the woods and river peeping with frogs.

On the Bruce Peninsula in August
the bats fly in the white pines
and over the raspberry bushes.
Stars shine into the window of the second floor
where we sleep. The Milky Way
flows into the house all the moonless night,
rivers of light in the darkness over our skin
like a parasol over our souls
lifting and drifting
in the lake of carp and minnows.

# THE HUMMER

In the midst of fragmented dreams
I am standing on the steps of the house at the farm.
The sky this morning is the colour of torn denim,
the clouds from the lake like animals on the run.

A hummingbird comes to the hollyhocks in long grass.
He gives a short high cry and drinks from the flowers,
wings loud as the sound of the mind
when it is racing past itself
into the place where night comes true slowly,
layer by layer of cotton batten lifted from the heart,
and the smallness of the light, released
with notes the birds sing at first dawn.

# Not you, yes you

One day you wake up, months later,
the storm has ended,
there is a softness over everything,
pearly light in the grass under the trees
in the faces of those you look at,
their eyes clean and calm.
And there is a beginning again.
The three tight bands around the stomach relax,
your spine straight as the pine pointing to the sky.
Everything is back where it was but new, taller,
as though the gift of seeing into things
has gathered itself and looked.

# FINDING YOURSELF

Days pass before you find yourself again.
The night sky over the city full of satellites and airplanes
and the band of thought that gets heavier and heavier
when the weekend is coming to a close.
The bars shut down, the sidewalk empties
and the wind and rain blow newspapers about.

What I wanted once was to start slowly then faster
effortlessly down an incline,
the power of gravity doing all the work,
like a perpetual machine in orbit around the brain,
racing it, phasing the light
so the body floats into the virtual gardens
of hope palaces
among people at parties
that started sometime in childhood
and have gone on into our future
where we can wake by just opening or closing our eyes.

What we saw then wasn't dangerous,
just the broken glass of windows,
just random shots of gunfire and fists
hitting bricks.

When the pain starts, it finally comes to this,
the silence that has been waiting inside
to come out around you,
doubled up on the bed,
the silent slowness like the switching
signal line on a subway tunnel
when there is nothing then everything
the roar of the sound as it hits you.

# TREE

The weight of the April night
casts shadows, cherry perfume
still inside the tree.
It is raining slowly. The rain
makes us breathe deeply,
moving up to the moon and back.
You are in the window photographing
the tree. The moon is perfectly still
for four full minutes, all ripe and round.
Men come and touch it for good luck
before plunging into sleep,
the male sleep of doves on a good night,
cool, full moon, a little rain.

# ALL NIGHT

When you sleep the body lies quiet
and restless by turns, turning all night
like a fish in a lake.
When you lie down, the eyes close
and you travel slowly
listening to the room,
watching the stars filter past the tree,
the blue numbers change on the clock.
You get up and walk to the window.
Darkness around a street lamp
and no one going by.
All night the river of broken waves
pushing you out into the deep part of the lake,
swimming, then swimming back.

# CONE OF LIGHT

The cone of light I live in solidifies into yellow night.
Outside, the wind is blowing down the snow.
The trees move like hands in the air,
low 20th century chords,
gathering slowness like a harp.

The alien wonders
creep closer around the light
wanting to be in the room.
They are engines of all sorts,
cars, and wheels under things.

The light in the room juts out into the street.
I am living inside a star.

# MIDSUMMER NIGHT'S EVE

The week before Solstice you feel the balance
changing. Paying attention again you see
night has not yet fallen. You are riding
home on your bicycle at 9:00 p.m.
and a sky of light moves above you.
It has rained and there are clouds but it feels early
like you could still begin your life, there is extra time.
Friends notice it too, everyone
feels the first glimmer of summer
mixed with the glow of rain. Tonight
at midsummer night's eve in the city's parks,
in sleep, in the shadows, transformations
will take place, animals into humans,
humans into lovers or into the animal-
headed forms that once lived on the earth.
Because nothing is ever finished, we can begin.

# THE BIGGEST MAPLE ON THE STREET

Underground the maple has carefully felt out
beyond the fence, out under the street
and has anchored itself against hurricanes
and earthquakes
and other storms.
Inside the roots, a body sleeps,
a skeleton now, 300 years old,
the bones of a man. Beside him
is a drum with beavers painted on the rim.
The skin of the drum was torn long ago.
The tree is lifting him slowly,
year by year,
up through the branches to the light.

# ℛOCKS GROW IN THE NORTH

Our fathers said it was hot down there,
one mile under the ground,
as they worked gold out of the stone.

Wildness in the heart of cougar and moose.

Ten years, twelve, we are back,
walking through the pine trees,
the smell of needles,
and mushrooms and water nearby.
And a bear has been here, left his spoor.
We walk down Government Road, whistling.
The land is hard like rock candy.
The ghosts in town are alive,
in the mines, in the rock,
calling.

# BLUE SKY

When you wake you come up slowly
towards the sun. The waves turning
over you, the current pushing you up.
Above the blue sky is a carpet upside down
which children see when they are born,
the day full of diluted starlight,
the birds in the trees on shore.

# HOME

When you sleep you bring yourself home.
There is a lamp lit
on a table in the old house by the lake,
the stars and moon pull across the dark
like silver chafing in the ground.
When you come here in sleep
you know immediately where you are,
in the home you made long ago
when you were three or ten and taking your sleep
as an instrument to play on stage
an instrument in the real world.

# BACK HOME

The rink man opens the ice shack late at night
and the fire leaps out into the cold.
We carve the ice with our skates,
under the string of naked lights,
our number eights and other figures
for the future that is spread out —
*Out in the world,* mother said,
*Inside the book of each of us.*

Climb the stairs. Upstairs are the sleeping children
and parents in each other's arms and the thin
voice of the stars speaking in the snow.
Night on the roof, lifting and falling with the moon,
we sleep in a deep dark place.

# ANNIE, FIVE OR SIX

The great blue day was turning yellow
and apple blossoms were blowing
in the transparent wind.
No one else was around to see.
Annie lifted her dress and peaked through
the thin fabric at the light. She was 5 or 6 years old,
and there was something wonderful
that she wanted to remember from a dream.
She could see long slender threads of light
connecting her to earth, and from the tree,
green-almost-visible tendrils fell in ropes
around her body, curling here and there,
around a leg, behind her spine. The bell
at noon in the church beyond the trees made
soft gold cries like her mother in the kitchen, laughing.
The invisible tendrils of the tree reached around her,
lifting her up and up into the air, up and up
into the sky, as Annie, watching through
the near-transparent fabric of her dress,
loved and loved she didn't know what.

# THE HEART WAS OPENED

Rain is falling.

Up the long road to the north, the gray
spreads over the great yellow field.
The road climbs high up the map
past the Woolco in Durham,
the variety stores and corner stores
and donut shops all the way to Wiarton

in grey rain.

And in the heart,
like a bulb in the soil,
a small yellow shoot
is growing,
with its closed purple
flower pointing to the sun.

# $\mathscr{T}$OUCHING WATER *(for Faye, Ann, and Lorraine)*

The hillside is crowded and noisy
and we are trying to speak, and can hardly remember,
in the din and singing and crying and laughing
what it is we want to say. The hillside is spinning
like Fasie's musical carousel. We are going
around and around in the music, and Lorrie
is laughing to stop, and Annie is yelling to go faster.
The sun is turning with us and the hillside
is covered with horses and dragons
and two small unicorns,
and a dinosaur is waking up the ground below.

We are yelling and dancing, and hearing
the sun turning the earth around as it holds
a high voice and a low deep sound together
and makes a cable of the voice so all the planets
can be whipped around faster and faster
as it shifts a little like the heart shifts,
closer to the centre of the body
where women get fat and there is no more room
behind the breasts that are large, and float
like dumplings to the surface of the water.

When mother makes dumplings,
we crowd home for lunch and it is noon
and summer is beginning
and we are not women, but girls,
and our mother is as great as the goddess,
who comes to rescue lost children
and takes them back to where they started,
and helps them forget
what pain made them lose their way.

Fasie and Lorrie and Annie and I
are sitting in the windmind
and it is blowing us together
on the hillside at the very top,
where we are crowded with
all our children and sisters
and brothers and fathers
and mothers and friends,
and all our generations back
to where the memory falls dark
and we can't remember.

*The phrase "Touching Water" comes from a poem entitled,
"Pictographs", by Faye Scott Rieger*

# GOOD FOOD

Chicken and potatoes baked until
the whole house smells of inhaled earth.
The stars send white lines down into the ground.
You walk through the yard and open the gate.
The stars move through you, swift
then swift again. You are not even tired yet.
The chestnut tree stands tall like your brother.
The babies of the garden feel with their feet,
they move over everything
pulling it slightly to the right
and then to the left.

The good food is for us. We tell ourselves a story.
Mother says, one more bite
and then the child will grow
big as a potato in the ground.
She serves our meal on the rose-patterned plates.
Here, let us make love with spoons
slowly together
(I copy the motion and you copy the motion).

We are deep in the centre, fixed and very slow.

# THE AIR IS NOT THE SAME

When mother reads in Russian from the Bible
afterwards the air is not the same.
We are embarrassed.
The air is thick like white cream, the
ivory of mammoths, cast yellow dice
on the kitchen floor. When mother reads from the Bible
the stove is whiter, the lace on the windows
in December hisses and breathes.
When mother reads Russian,
the star that hopped high over the house
hops back over the chimney.

# A LANGUAGE *(for my father)*

He holds a rosy, sometimes blue
place on the periphery of language.
A handful of concrete directions
for need. *Bread* is enough.
*Hello trees and grass,* is enough.
*An orange umbrella for rain.*

In the fields, wet loam
with no English equivalent
so he hears the sound of footsteps
as they are visible
wind etching the mind with freshness
each time, so he sees
the speech of leaves, a language
as familiar as breath.

And the cry of the redwing
is visceral endowment.
A stone thrown into the river,
silence itself,
a vortex of beginnings.
And handshakes with his own children
because words are at different speeds
worked into the muscles
so the hands know
what the voice can't

stories, if you listen.

*John Kaszuba, 22 June 1913 - 29 April 1983*

# SMALL WOODEN HORSES

My father carved small wooden horses.
We were on a train
and he was making the first small horse
of the new world
on which to ride over the rocks,
through the streets of gold,
and into all the small tar paper towns
along the line of evergreens
that start as soon as you pass North Bay.

When you go North,
the heart and the head
are one great piece of granite,
where you should never come.
*Unless you are in love with a man*
*who is behind you and ahead of you*
*and everywhere in your body.*
My mother said this afterwards
whenever she spoke of my father.

We travelled together to the edge of the world,
the last place we lived in transformed
into a small wooden horse,
a child's toy my father carved
for each of his children.

I am in the circle of small wooden horses
my parents' daughter, a dram of distilled sleep,
their future, travelling south again.

# $\mathcal{H}$E WALKS OUT OF THE PHOTOGRAPH

Underneath the chandelier,
space is emptying itself.

We dance under the lone
star of the night, father and I.
Rain sky, great black envelope.

He lifts me up. We sway.
He dances me around the room
by my waist. I almost step on his feet.
Harry Belafonte sings *yellow bird*.

I stay in the air
afterwards a long time.

# *S*UNDAY  *(for Roz)*

The bird outside my window
is singing high in the tree.
The end of a street is something terrible.
Who would go there and come back?
Who would go there?

We skip and play on the black sidewalk
where snow will fall. White
is the colour of settled things.

My heart has spun out onto the floor of the room
like a child's top. The map of
the world on its surface, spins. It spins
a long time before it falls and I pick it up
and put it back. It goes like that,
big as a saucer on its edge.

*Rosamond Ann Austin, 18 June 1948 - 5 October 1997*

# NEW COUNTRY

When I was little
the country was white in winter
and the summers were green and red
like ribbon candy.
A hot sun sat in the west
and went home like a roller coaster.
As children we had secret names.
A secret could be kept or given,
it was good either way.
Some of our parents drank,
some beat us, some were good and kind.
We grew wild
like grass outside the fence.
When I was eight, the stars were coloured
lights I called by name.
Nobody noticed how we lived.
We sang ourselves to sleep
in old beds against windows with cracked glass.
The air was wild too
in the white country of snow
up in the north.

# PRINCE EDWARD COUNTY, IT IS SO LIT UP

*Come up, Come up.*

I follow the boy with the beautiful strong legs
up the ladder.
I climb up to see his face.
We sleep together in the dark,

deep dark, we sleep.

The stars in Prince Edward County in July
more than anywhere I've seen
fill the lake,

whole lake of stars.

# STRING OF BREATHS

If you position yourself
in the middle of the yard behind the house
near wild patches of grass,
with clay ground showing through,
and it has not rained in the last week,

and if the fence is painted green
and it is the middle of the afternoon in June
and the clouds above are moving
faster than a train pushed by the wind,

and you are thirteen years old and stand there
with your whole body perfectly still
so you can hear your heart
and the hearts of the people all around you
in their living rooms and bedrooms,
washing dishes, and crying into their hands,
and laughing
because a child is speaking her first word,

then, if your body can be quieter than in sleep,
in the place between breathing in and breathing out,

then you will be everywhere,
forever in that moment in that place,
the whole yard lifted with all your breath
and the trees beyond this,
and the houses, and the singing hollow caves
beneath the town where the mines open
tunnels underground,

then holding your string of breaths,
you must give understanding
to every heart you hear beating,
so it will keep beating

or the hearts outside the yard
will lose power, lose quiet,
and you will look out at the street afterwards
on the glorious greenness of poplars, and see
only the pieces of the broken engine
in the neighbour's yard,
and not the shimmering day,
lost in the crush to finish,
to reach a door and open it
and enter and close it behind you.

# In the Georgian Restaurant

The rainy world has a centre, a dim dark shaft.
Thoughts we wanted to dull fall through the body.
On Burford Street cars move up the hill to Tobermory.
The arborite green marble counter with bottles of ketchup
salt shakers, sugar, has four people at it.
Saturday afternoon, lost time accumulating slowly in the ai
ghosts of everyone, shells of discarnate
subtle bodies discarded in the restaurant.

The radio plays a tune with a circus calliope in it.
The waitress talks of the weather,
rain on a slow Saturday
with wet tracks on the chipped tile floor.

# JUDY, PREGNANT

I was 13 when Judy was 14.
She was blond like the crusts of white bread
she loved to eat.
She never talked.
They went together under the moon
and he pulled her apart
like chicken bones and she opened up
like children do
when they are promised something
and they breathe through their mouth
to hear it better. Judy opened up
like a child promised a toy
or a piece of cake,
or a chance to go to the show.

# FOR MY SISTER

My sister dreams her beauty every night.
The light in her head
hurts. She is red. She is cold.
She knows the surgeon's hands
opening the pain of her face
lifting and shifting the brain.

The poem of her face folds
into the rooms of the heart
ancient as beryl, as ruby.

The opening of her head
in the night
for a soft-hard mass
big as a golf ball, the doctor said
making a circle of his finger and thumb
as big as this.

# SUNBEAM BREAD

I had a friend when I was ten.
In the house where we played
was a piano and a cat and a staircase.
A house with a staircase lives differently
from a house flat on the ground,
like iced tea is different from Yukon tea.
One can voyage through a house like that
past secrets, and rabbits, and baby cats,
and people who came across the ocean
to end up in a town in the bush
making bread in the factory just down the street.
A bread full of sunbeams it said on the wrapper
with a picture of a girl who looked like my sister
and behind her the wilderness of blueberries and rock.

# As CHILDREN

The good and the bad
sleep together in a song.
The stories we were told
move slowly in the sandy dark.
They breathe
under the green skin of the lake
through rivers
slowly over rocks and roots
until they surface
shining with drowned stars,
and tears and blood.

# RUNNING IN HIGH HEELS THROUGH THE NIGH

Outside in the parking lot, where boys whistle,
we hurried over the asphalt in high heels,
healing ourselves as we ran.
Life wounded us under the ribs in the places of youth.
Along the road grew houses, little humps with light
some silent, some full of old lightning and house love
from which voices called us home, *Beatrice, Isabelle,*
*girls.* And we stopped, stumbled at the edge
before the road sinks into the empty fields outside of town
places that go on, heart purr, lonely
down towards the syncopations of the Last Love rock band.
We chose our handsome lovers by their rage,
their arms and muscle, for the sheer joy of speed.
Sound in its long note wails up the body,
echoes in mirrors along a wall, colours the organs of thought
We stopped as we ran to see ourselves, burning with desire,
flowing through the salty nights, floundering in the afternoons
in dimpled light, in front of TVs built for two and three and si
a saltiness, lifted out of the dayself, a green perfume of place.

See how we look out into the vinegar rivers, vertigoes of nigh
from the superstition in the language we invented
men we would know, children we would have
looking back to see ourselves as we run through the night.

# SHE BECOMES A LAKE

Push away the flotsam,
the log moored in stagnant water,
the debris of picnics,
and the old paddle lost in a courtship,
now silver driftwood in the shape of a fish.

His hand drifts over her shoulders,
on the waves of her body.
She becomes a lake he looks into,
dropping each photograph
to float on the water:
a child with his dog,
a boy running in the field,
a student over a book in dim light.
The papering of water.

The pictures float side by side
sometimes two, one over the other,
slightly in a ladder,
sometimes swaying,
or the dog and child lifting
over the field of bobbing waves.

In the landscape, shadow whispers,
the man and the woman together
in each other's light.
The flesh full of dark water
where tears are resting, drop on drop.

Push it away into the river
that drains this place,
flows quickly down the table of land
over the quiet boulders ice left when it moved
its hard animal quiet back into death,
foaming, white and clear,
breaking up the still pictures.

The river moves underground,
spreads itself on a large rock
and resting its millennia there,
bursts out of a crevice,
a spring we drink at.

# PAIN OF FRIENDS

The territory of the self is deep like Canada,
with ice in a cave under the earth
and frost on the walls of a darkness
full of immensities.
Snow is falling out of the stars
and the silence is full of tin.

When we sleep, pain tears out
another piece from the heart
until by morning
we are full of holes
and light comes through us like a train.

# FROM THE SHADOWS

The dark garden was hidden by a tall white fence
that made a ring of moonlight in the city.
We sat there, music on the radio in June,
the light from the kitchen window
and the light of the stars
falling on the grass like clotted cream.
Outside the circle of my arms, the shadows
were short and thick and filled with longing.
I made a white shadow of my thought
and pushed it through the dark air to you
and you pushed it back so hard
it snapped through a twig, and fell torn
and tattered like an old piece of lace,
light as a spider's web.
As I picked it up quickly, without looking,
and pretended nothing had happened,
I saw the animal's eyes. And again tonight
when I was longing to pull the sky
down over us and find you and hold you,
I saw the animal looking at me from the shadows.

# WHITE FLESH OF WATER

They are sitting on the beach,
three women rounded like boulders.
The water echoes their thoughts,
waves like white animals running to the shore
and back out towards the sky.
The women sit large and silent
watching their children.
Clouds in the blue sky
sail large thoughts over the water.
The lake whispers and sings. Sounds
of grinding teeth of those that are hungry
and hunt with animals.

In the deep ring of trees around the lake
shadows grow deeper in the centre.
The smell of crushed pine needles and
the queer subtle smell of all the animals
that have passed here, leads deeper.

On the shore of the lake the women
call their children back from the water's edge
where they are watching carp
roil in the water, *making babies*, more carp,
the white flesh of water and fish and sun
shining together.

# GEOMETRY OF ROSES

Behind the woman's eyes is a coastline
the waves come in from an unimaginable distance
edged with salt
the man is naked beside her
around them the sun blows
white like a curtain

The man and the woman are swimming.
The woman is a mysterious shape
his hand is a voice over her body,
there is a layer of water between them
her breasts are two thoughts
drifting through his hands

# THE WAY BETWEEN THEM

The way between them is like this:
he takes his large hands out of his pockets
and wants to hold her. Coming over the three feet
of dark space between them,
his hands drop down,
and rest on her shoulders.

This happens at different
phases of the moon. Sky will be heavy
with stars and very black.

He releases the pain in his body
and it floats, settles on her body like a mist.
Little seams unravel in the fabric.
Zippers. Her shoulders let her body drop.
She steps out, the dress at her feet.

# Moth

In the lighted room
at the top of the house
a moth beats against
the window.

Great powdery wings,
a desire for light.

We touch each other silently
in love
the way
ideas float over ideas
and alighting
are gone.

# A DOUBLE FORM IN SPACE

I watch two lovers watch each other.
She nibbles food from his plate.
His head is tilted, smiling.
She tosses her long black hair.
They spent the night together. Their love
is new, a double form in space.
They have not started yet to edge away.

At the beginning of love,
the stars travel down
the body's wiring to the heart.
In the heart, the soul
waits for the other, watching.

# COME TO BED

Inside the golden city of touch
a medieval world rises up,
a place in the stars

Your dark head dreams,
a drug for taking time away
lifted up in layers from the heart
(weights and weights)

I carry linen in a pile up the stairs

*Come to bed, come to bed*

the night is white
the stars shift down
swift gleams into our bed
(along your arms, along your back)

*Come to bed*

# BLADE OF GRASS

today a blade of grass could chain me
anything your eyes ever looked on
in this world full of guesses, could
if remembering could bring you back

do not break bread
let it be grain
a little longer,
a white root in darkness
green gold body in the wind

do not mill it for flour
or consume it
let there be the savour
of a last imagined feast

let us be hungry a little longer
before dreaming is consumed in flesh

# THE UNFOLDING

When snow comes and stays,
and it is January without love,
we break ourselves into tiny parts.
All our friends have lives linked
by hooks and threads to each other.
The fire in them gives a small warmth
like a puff of breath into the cold.
When we go alone into the world
we grow branches up into the air
and when we go together,
we put down roots.
The secrets are there all about
like the meaning of words we say
as we are turning to see.

*How are we made?*
First and last, from the bodies of dark pain
of men and women with steel bones, and teeth
for breaking down the hard grain of the world
into love, its white bread, its fine black seeds,
its oil both blond and black.

# PEARL EARRINGS

All night the pearl earrings dream
dream in the river house.
A tiny hole through each
the jeweller fixed
with a gold wire
to a small gold screw.

It's the problem of love to them.
I know. It's the problem to me.

They wait in my ear
like a hymn singing
childhood to me.
I too am from the river bed
pierced through with a golden thread.
We sing all night in the house of night
of Christmas and the god of light
all night of you and me
we sing the breath take us away.
We sing pierced through.

# TOMMIE AND LIZZIE

The world of the soul is small, narrow and very fine.
You go in single file on and on
towards the distant light.
Tommie when he was born remembered it,
and Lizzie spoke about it till she was three.
Now they're seventy and seventy-five.
Why should they care where they cared before?
What can they do about their death?
It's there in a room waiting
at the end of the night.
*Is it in you? Is it in me?* asked Liz.
When she was forty and strong in her faith,
there were her prayers.
Did they go where they were sent?
Will they come back?
Tommie and Lizzie know a thing or two
and they remember some of it
in the shadows at the end of the yard
where the grass is high like the fence
and fireflies glow in the night.

# BLUE DEVIL OF THE LAKES

The deep blue devil of the lakes
comes when we are young
and tempts us with the bitter and the sweet
which mixed together tastes of air and flame
and not of mortal life.
And later it is never the same.

# THE FIFTH THEOREM (for John Czuba)

Time detaches itself into small islands
which float to the four corners
of a lake the size of a country,
rise out of the water and become land, part of the shore.
Millennia later when Euclid begins his geometry,
first one theorem, then another, then a third,
takes shape like an island, and at the fourth
you are following Euclid's white lines
on the starry heavens joining planet to star
to celestial penumbra.

By the time Euclid discovers the fifth theorem,
power has passed down through the firmament
and is on earth flapping like a large canvas sail
on a lake at noon with strong winds tearing
the water up into the wet flesh of a muskie.

By the fifth theorem Euclid has given birth
to a gargantuan idea, with writing
all over the map of its large body, shaped like a whale.
A fountain blows from the hole in the head
as it swims up the St. Lawrence,
past the oily lights on the banks,
past the docks and shipyards,
all the industry locked under sweat and money,
and the hook that keeps everything in its place.

By the fifth theorem, Euclid has lifted the sky up and down,
five times, back and forth, between heaven and earth
as an exercise in beginnings,
such as ideas are before they grow rigid,
like the greenness of the tree is,
first out of the ground beside the stream
when it is leaf, before it is covered with bark.

By the fifth theorem Euclid has paused
before the man and the woman,
between the straight line and the curved,
and is drawing with his hands in the air above his bed.
In the circle, he will enclose the first and last breath
of moonlight as it breathes in the water,
the first and last breath,
on a midsummer's night,
breath held and then let go, large and full of vowels
in the nights of singing, when men and women
call back and forth like the wind does on Baffin
and up in the other lands of the north
when it comes answering the dark heart
making black circles in the earth.

*John E. Czuba, 25 April 1947 - 14 June 1979*

# GESTURES

When it's early in the morning and you haven't
slept on the bus from Washington to Boston
you begin to get funny thoughts.
Usually you think you are someone else,
feel it with all your mind and body, begin
to jump hurdles in your thoughts
inside the darkness of crowds and strangers,
making small gestures with your hands, the kind
the gilded statues in the Mongol exhibit show,
with the hands pointing left and right,
up and down, cleaning the air,
the place inside
with its old rivers of grief,
yours and everyone else's.

# ANGELS AT THE CORNER

We follow each other. Sometimes I'm first, and sometimes you are. The squares of light from the stores and taverns and the restaurant where we eat fish and chips fall on the street; and the music from the saxophonist on the corner and the Quebec City violinist in the doorway, breaks high over the traffic, pauses and lifts, then floats.

The hammers under the street hit into the electricity so it flickers on the world of sewers and piping (cool wet steel and copper), and on the mice of the subway running on the rails. Above the tunnel, among the trees and stores, in the dark envelope of the night full of holes, the angel with the broken wing, and the other angel with his naked body, are at the corner of Dalton and Bloor just waiting.

And something like a small wooden hammer with a green felt underpad, is tapping all over my body as I'm watching you run back and forth, between the 13th and 20th centuries, between your place and my place and some place in the future we are trying to get to.

# UNDERGROUND

Devils are old and have streets
at the back of the city where nobody goes.
But she went. There are things
bigger and older than she knew.
When she first went,
she wasn't afraid.

She was beautiful in a dress,
with hair piled up,
and little diamonds
twisted in the curls.

Now it is midnight all day
where she hears the howling,
echo in her chest and up her legs,
for the words are fire and she is grass
and animals are running
without looking back
for little ones and friends
and she is yelling the truth
as she runs.

# ISLAND OF SUMMER

We are sailing to Paradise.
The sea is filled with creatures,
squid and whales and large sea shells,
and over there is Noah's ship,
beached near the lighthouse.

I am looking out at the Sea of Marmara.
The Turkish lights of Istanbul
fall in pink dollops, in blue drops,
in yellow white showers.
A salt mist hangs in a soft curtain
everywhere at the edge of the hot evening
and lightly, minutely coats the skin
so when you lick your lips before drinking, there is salt
and when you lean over to kiss, there is salt.

The cargo of the future
is in a deep wooden trunk on board.
Inside is our unblemished dream
like a white linen tablecloth
folded carefully, which we will open, shaking out
the whole body of desire, and spread it on the table
in the splendid room on the island
behind the northern trees,
white pine and apple around the house.

# THE GREEN GLOVE

The self is forgetful and doesn't
know where it can live:
in the blond hair of a woman
long and flowing
through her lover's fingers,
or in the fine light around
her brother's body or in her sister's eyes
veiled, blue and dark

or in a glove.
She puts on a green glove
like putting her hand into a tree
an arm held up for birds and breezes.

The roots call from below
a great beating in the heart for something
more to come down
or they will weep for it.

The glove is green,
a great beating in the heart for something
more to come down: a sound
from the middle open in each leaf,
aerial, played into
so the tiny flute holes sing

and that's how she came to be here
putting the green glove of music on,
song down to the roots at the feet,
singing to the red giant of darkness.

# THE HOUSE OF LORCA

I visit the House of Lorca up in heaven
in the place of the Christians who live
side by side with Moors and Gypsies.
Lorca fills the sky with his voice.
It is dusk and the water in the fountain is falling
slowly in the darkening square.
Lorca's music is a green circle
where bougainvillea falls,
as his music falls, over and over again,
down the slow curves in the dark, the way
the Madonna is worshiped behind the green Christ
with her blue cloak like a sheet of water,
like a mirror birds look into when they sing.
The poem of Lorca is singing with them
of the glory heaven is, when we open,
as he can open, his eyes in the darkness
and see God and Christ and Mary
who is always with him
with her hand on his arm, speaking
of the resurrection of the body,
of the body flared into light like a word.

# LAUGHTER AND OBLIVION

When you are tired of travelling
under a pseudonym
through strange countries
and want to be simple and dull again,
you long for work and the people at work,
the common daily sharing.

When you go home,
after a day in the fort at the edge of the world,
you run with the wind of the Gobi Desert
dreaming oriental images
filled with laughter and oblivion,
time pulling apart the animal below.

When you wish to outrun the dull steadiness,
the heart opens the door loudly at night
and you are riding the elephant of loudness and telepathy
and the band at the front of the restaurant
is playing cool funk jazz in a room
of people telling each other their dreams
and you are there, listening
to the wind blowing sand against the tents.

# LANDSCAPE BEHIND THE LANDSCAPE

If you take sleeping pills, you pay attention differently
as if your body was a doll and you had to move
all its parts from outside. The hair is
combed slowly, braided and pinned up
like in the old family pictures from the Old Land.
The Lutheran minister's wife is sitting
in her best silk dress with her hair in a
wreath on her head. By the Baltic Sea,
the grass on the farm sways like water under light.
The cousins play in the yard under the poplars
pulling apart a fort built yesterday in the war.

When you feel you can't put both hands
around your life anymore you go elsewhere
into the landscape behind the landscape you
can see with your eyes. There is sunshine and
a road to the edge of the lake in the woods
where the fish come to the shore to watch
humans looking out over the water
thinking with them of the pleasure,
trees and shadow, of the deep sleep of water.

# THE SCAFFOLDING

I am up in what will be the 12th story.
Just air up here and the kind of silence
that belongs to you when you are forty
and have put away the noisemakers,
have sent the wild ones home to sleep,
have cleaned up after the party and are waiting.
At first you wait, and nothing happens.
Then slowly you begin to turn the building
into a thought. The scaffolding is delicate,
there is nothing above the 20th story
but below the main floor, the building
sits on foundations deep in the ground.
Pull down into the basement,
under the first poured cement,
mammoth bones and the bones
of Cretaceous amphibians and fish
are embedded in the rock.
Make sure the corners are perfect
and the building sits squarely on the earth,
then move back slowly,
up the scaffolding to the top.

Start to see what should be there,
the purpose and the beauty of the place.
And how, in standing, even for a moment
on any of the future floors,
guests will be awake for an instant
in a sort of tremor of recognition
of what their life is on that morning
inside the form enfolded over love.

# AFTER THE WAR

We were lovers once in the street of burning lights.
We found each other again and again in the city of seasons.
The constellation of the bear was slapping on the shore,
great wet tanks were rolling up on the sand,
as we rolled in our beds, pulling
each other this way and that.

Months later, with recession and economics
and the small gates of Canada broken,
and the hole in the wall of the people's city, bigger,
we held on, blue body, green body,
gold piled up in tents out back and growing like grass.
We didn't know what had happened. The clear
glass where we looked to see who we were
was filled with smoke and trash and bits of
the broken star that had fallen at our feet
like a brick out of a wall.

# ANIMAL INSIDE

A siren sounds in the city street
speeding out over the dark.
Below, a war is starting, complicated, mechanical
(with the words for justice twisted into paper)
back where the sun is
the sun over Iraq
slapping against the white
walls in the *souq*.

Streets. Noon. We sleep. We sleep by the Atlantic
cooling our forehead where the horns sprout
and the animal inside, delicate and racing,
comes up breathing quickly and looking backwards
with one eye which has seen and seen
old things happen. The dead smolder
all night under the city walls
calling out the names of those
who should come to join them.

# Looking Up at a Window in Beijing

The light torn up into great yellow sheets
floats down in wafers, on air, silks,
Chinese light in Beijing through the windows into the room.
The small dark forms float up from me.
I try to hold them down, a calligraphy of air.
"Do not think," said the Chinese angel,
pressing the small of my back further into the chair.
I hold in a web: fish, (in the great blue sky
with a small clever hook) my small heron.

The salamanders flow through my fingers fast
all the bright ones around the body.
I float through them, my feet still on the ground
Chinese soil sifted through my body
yellow on the lungs, gold
in the brain, silt in the feet.
The salamanders take me with them
in and out of the lightning dance.
I am too big and then grow small, lighter, faster
a silk thread, a little blue like the Canadian air
and Great Lakes made me,
a yellow blue, in the China of old poems.

# RED AND BLACK CHAOS

When I open my eyes
she is standing, facing a painting
full of 20th century thought.
Small and square, stalks
held together by a thick black band.
The red in the centre would be chaos,
and has been in all the small windows of art.
A corner of the canvas is left white
for new beginnings,
which have quietly happened already
behind the news of murders
and suicides and genocides
behind the Latin endings of words.

Things that exist first fall out of the heart.
There is an aggregate of starlight
until the canvas is lit with it,
the will in it, of the imagination
to hold the picture clear.

# ℋCKNOWLEDGEMENTS

Much gratitude for reading and editorial advice over the years to: Robert W. Reid, Don Coles, Christopher Dewdney, Tom Wayman, Roo Borson, Libby Sheier, and to the Touching Water group: Faye Scott Rieger and Ann Kerr-Linden and Lorraine Fairley.

Special thanks and gratitude to my insightful editor at Beach Holme, Joy Gugeler, who found the book in the poems; and to the others at Beach Holme Publishing.

Also thanks to the magazines and editors who published versions of some of these poems: *Acta Victoriana, Arc, Dimensions, Event, Jones Av, Malahat Review, Next Exit, Peckerwood, Poetry Canada Review, Quarry, Queen's Quarterly, sub-TERRAIN, The Antigonish Review, The New Quarterly, University of Windsor Review, Vintage '94, Vintage'95, Writ.*

Printed in the USA
CPSIA information can be obtained
at www.ICGtesting.com
JSHW080004150824
68134JS00021B/2280